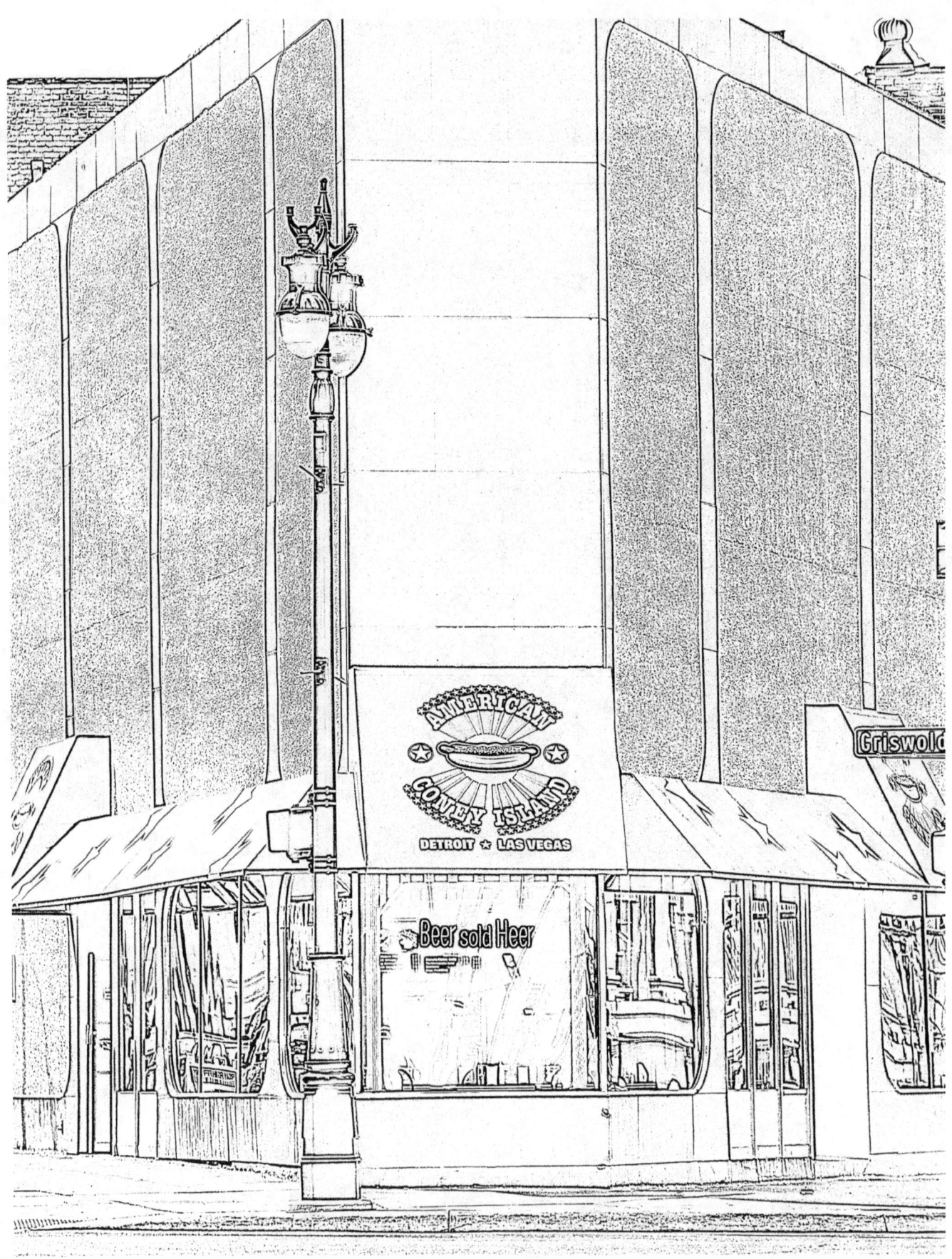

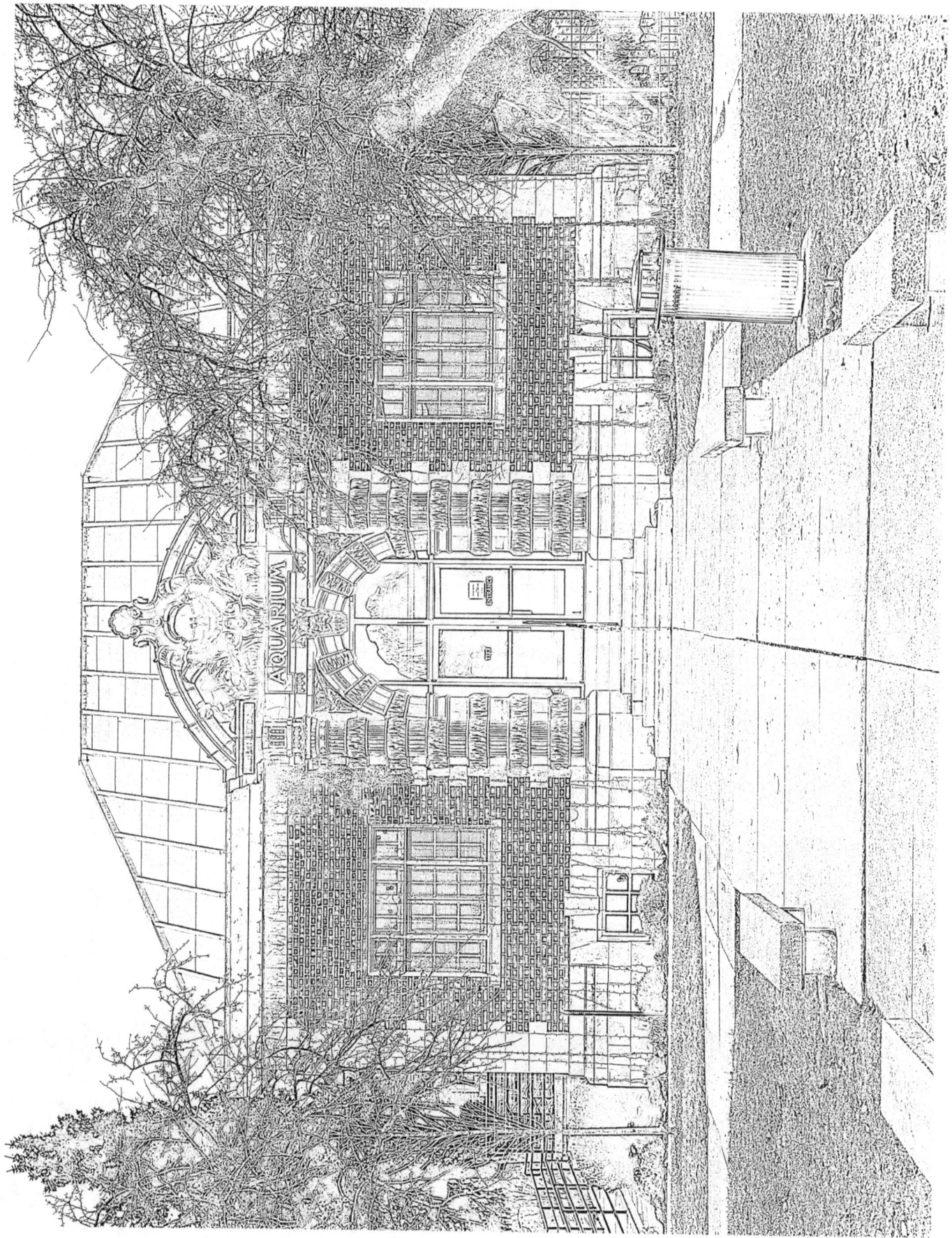

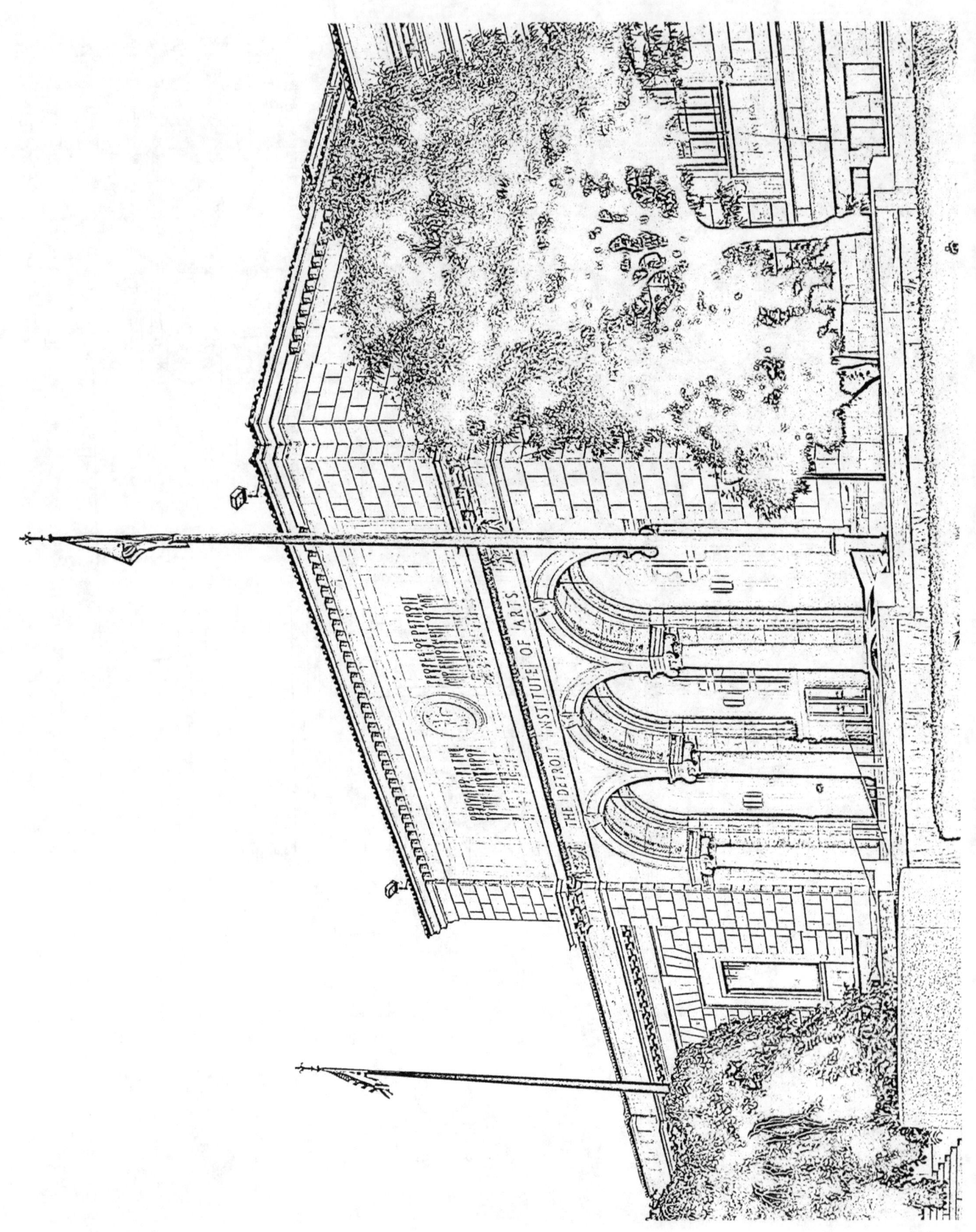

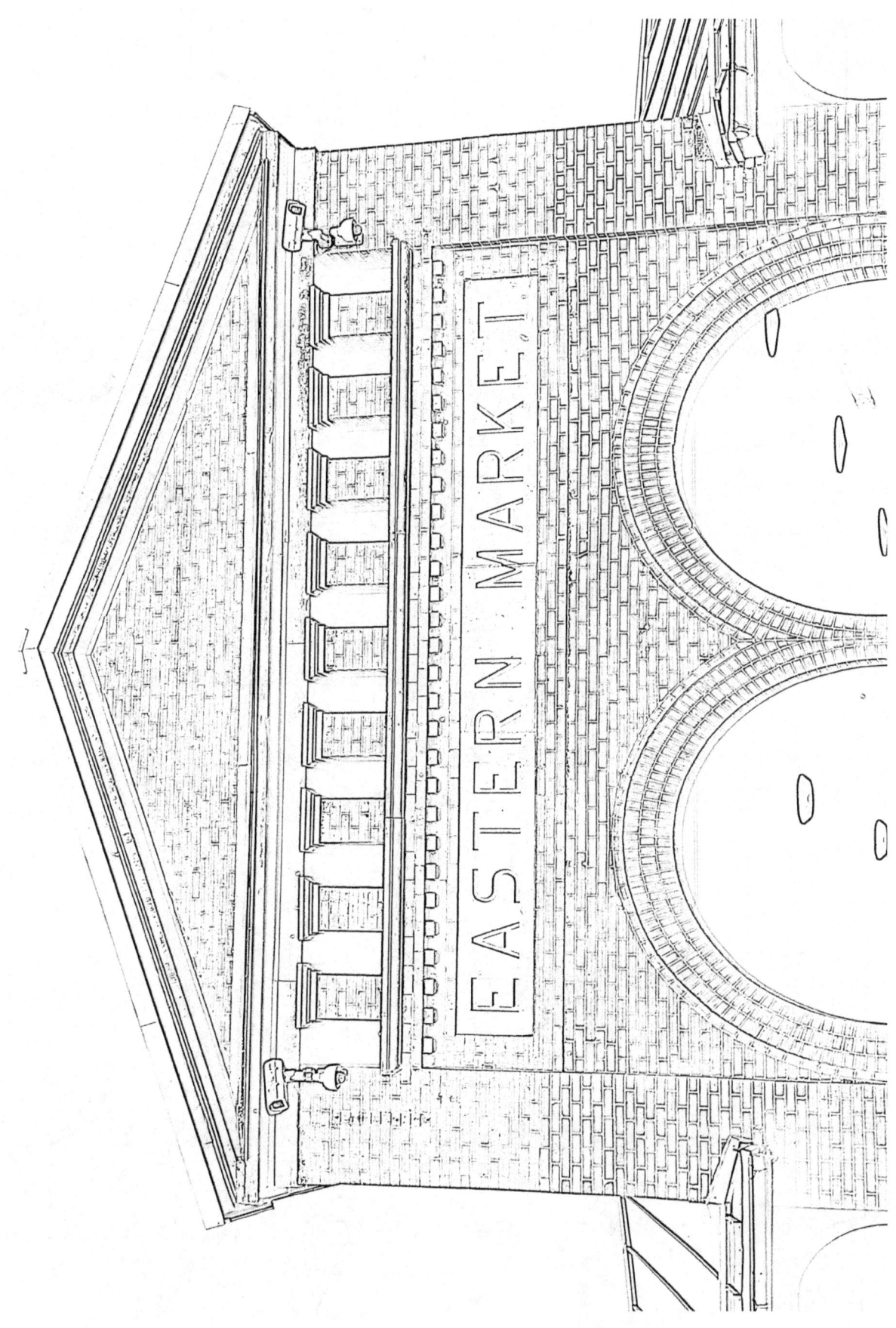

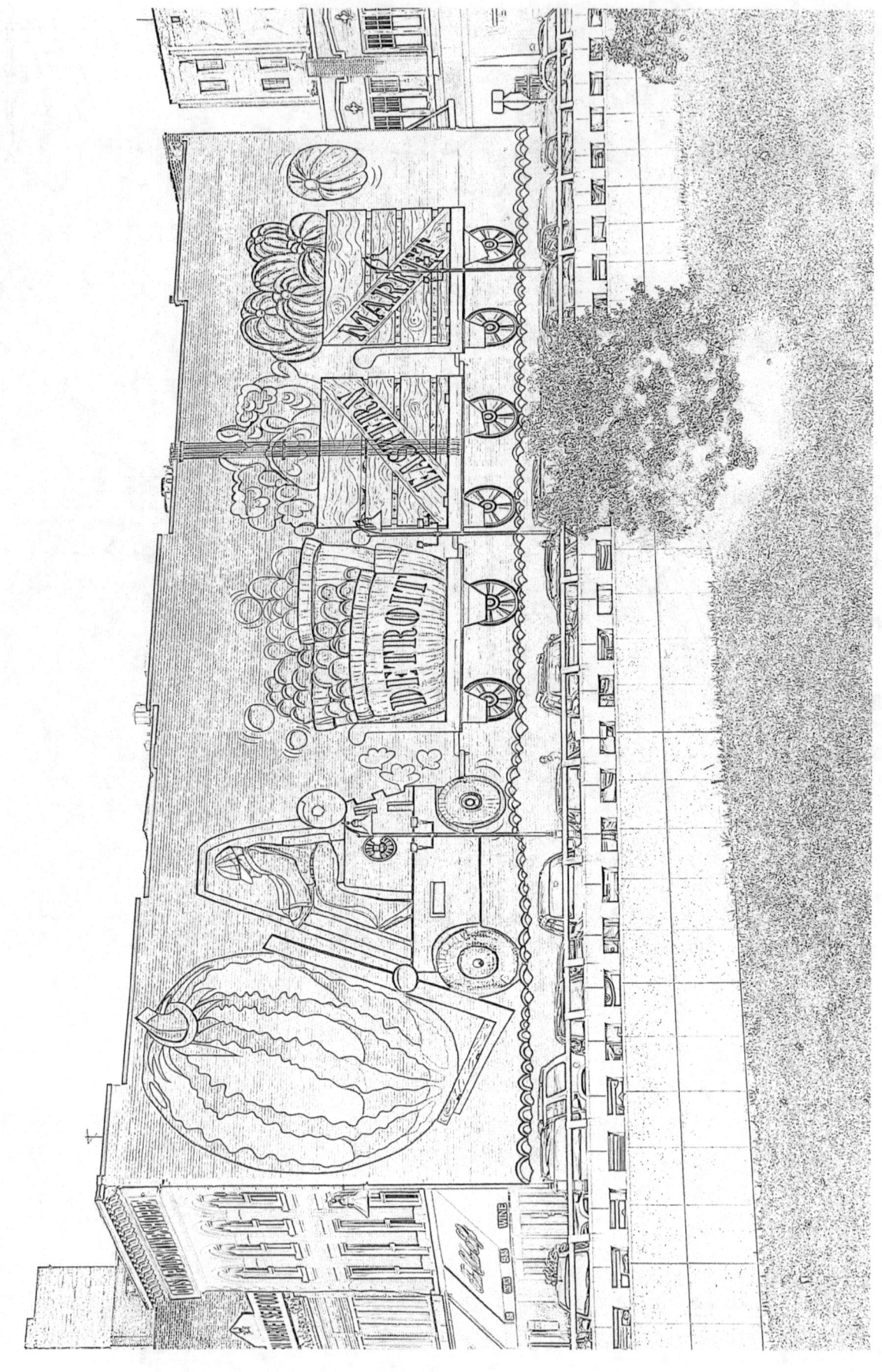

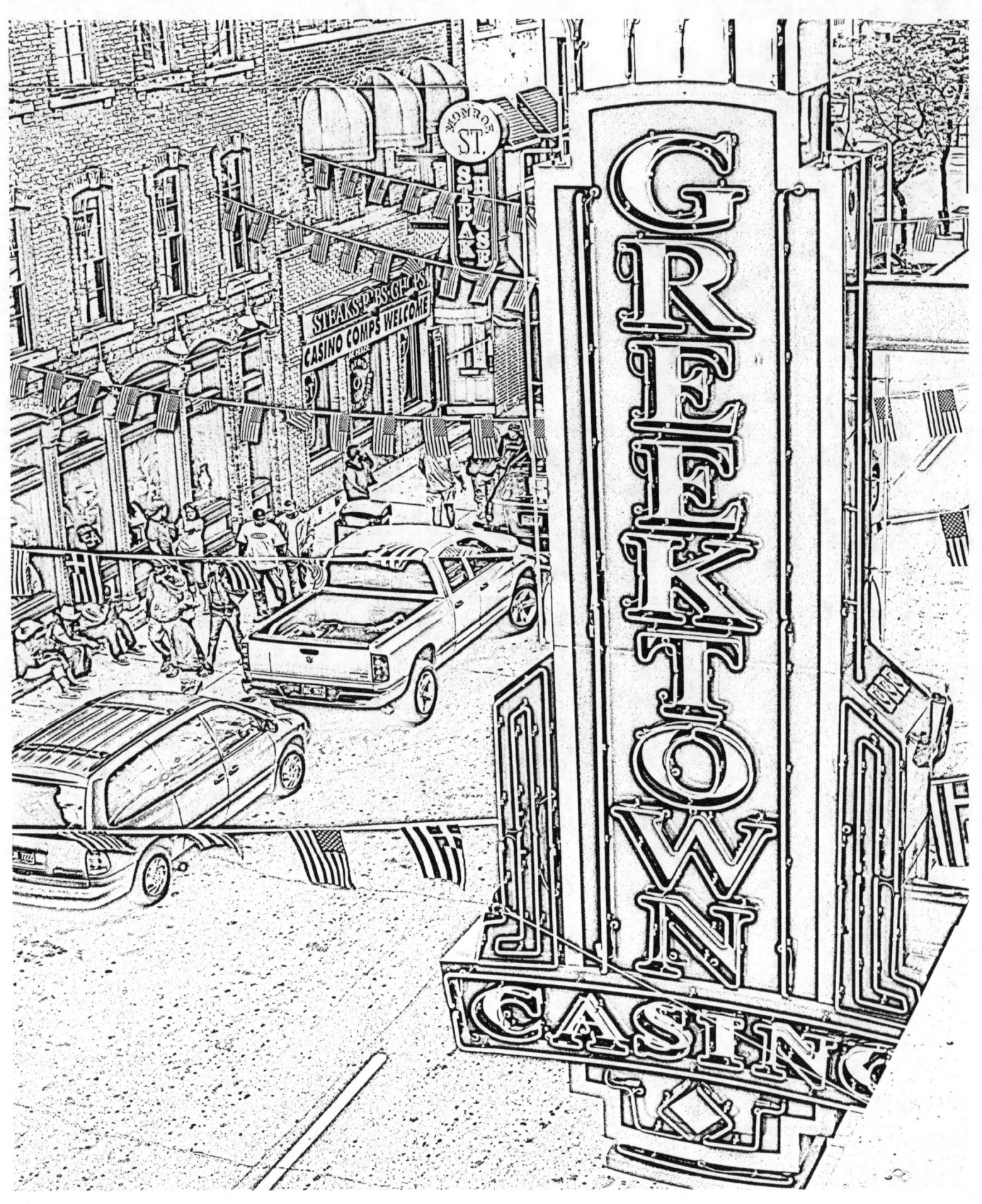

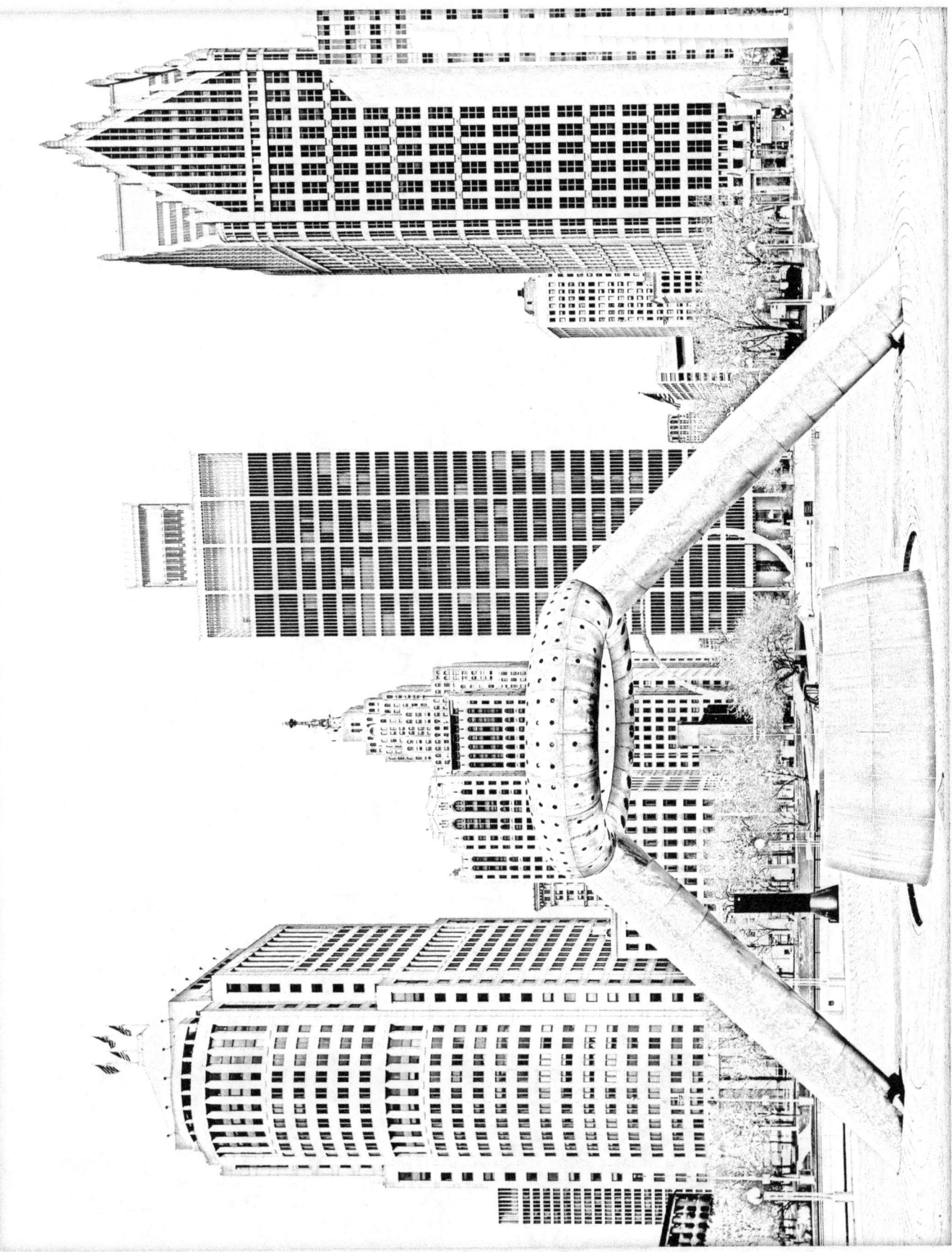

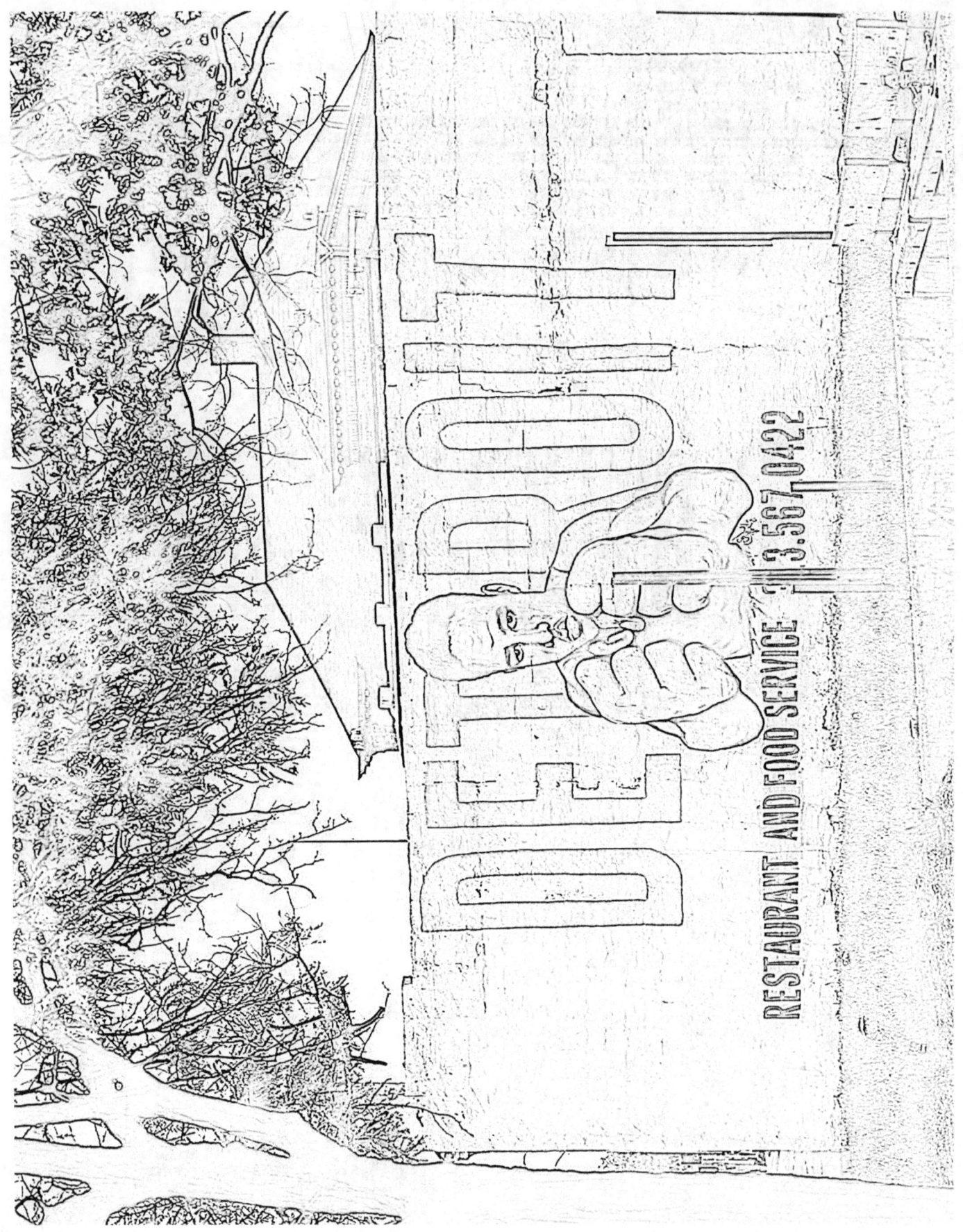

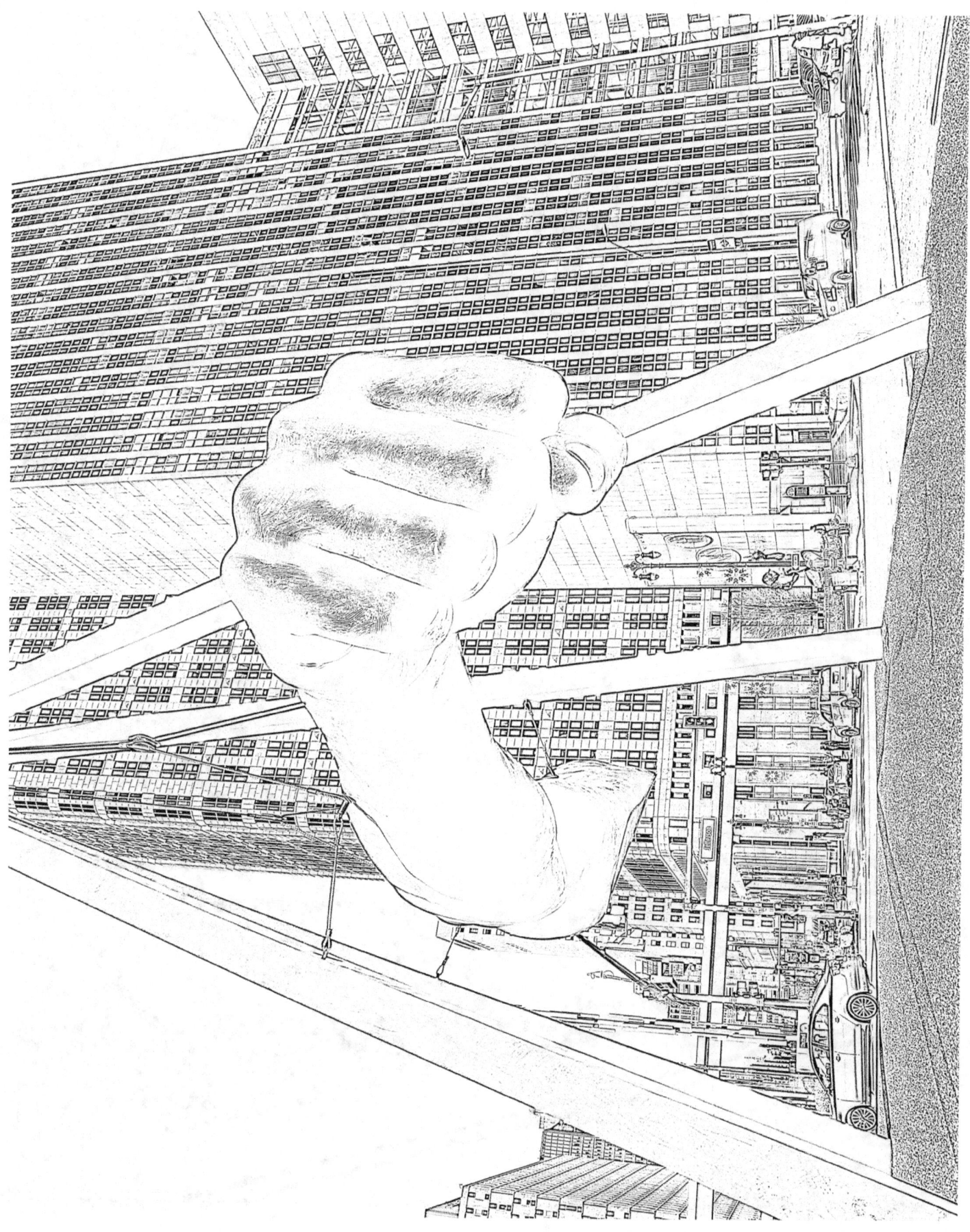

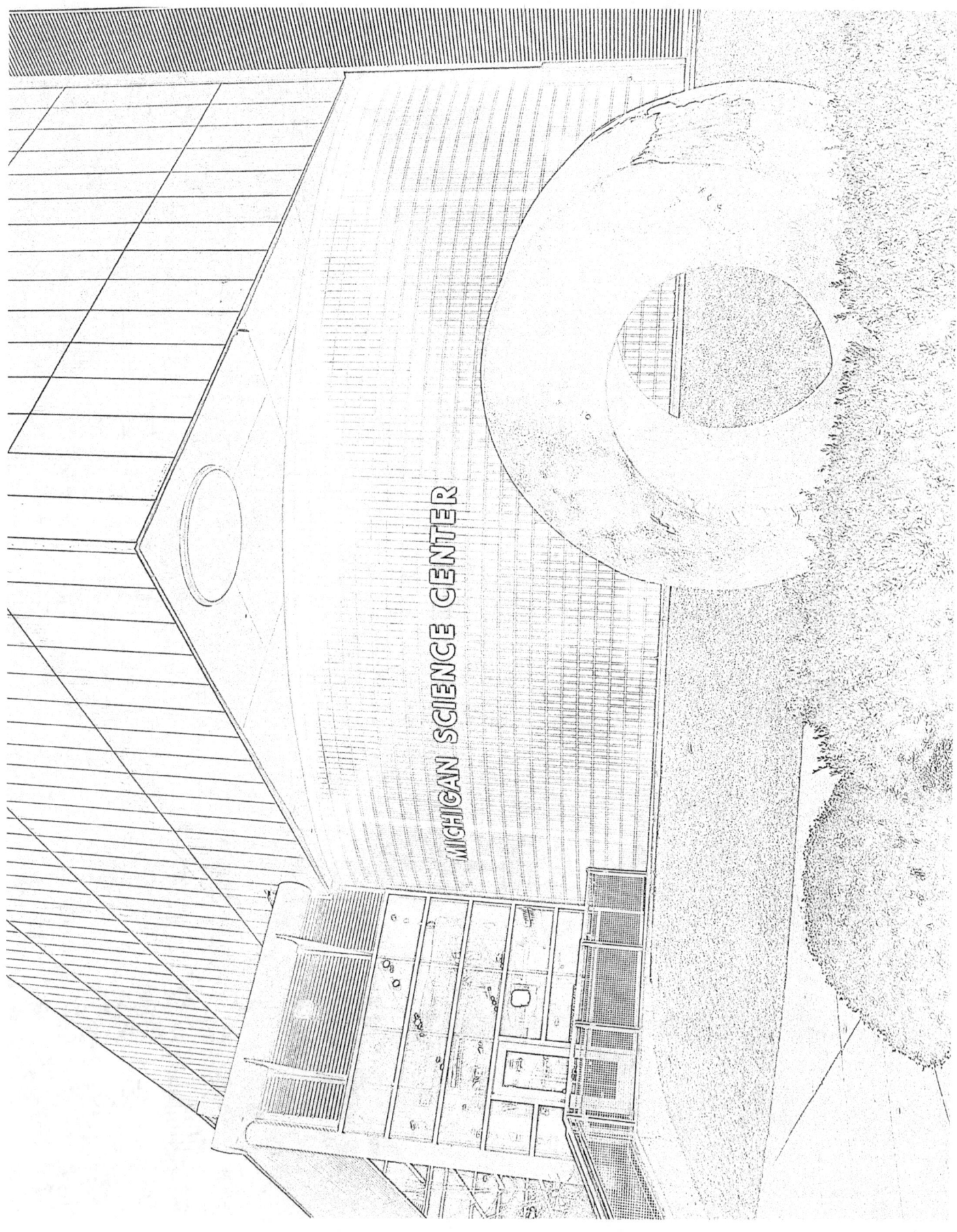

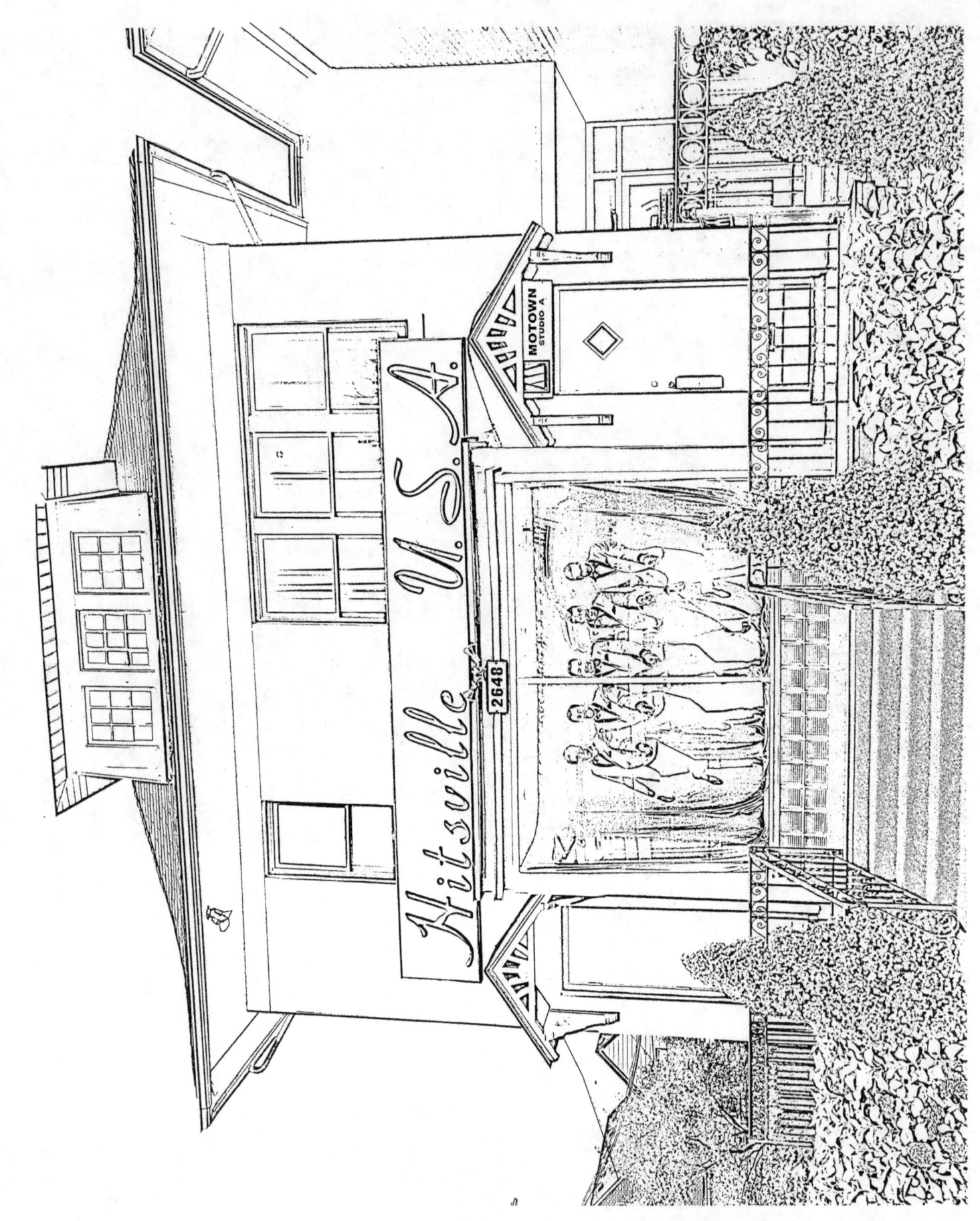

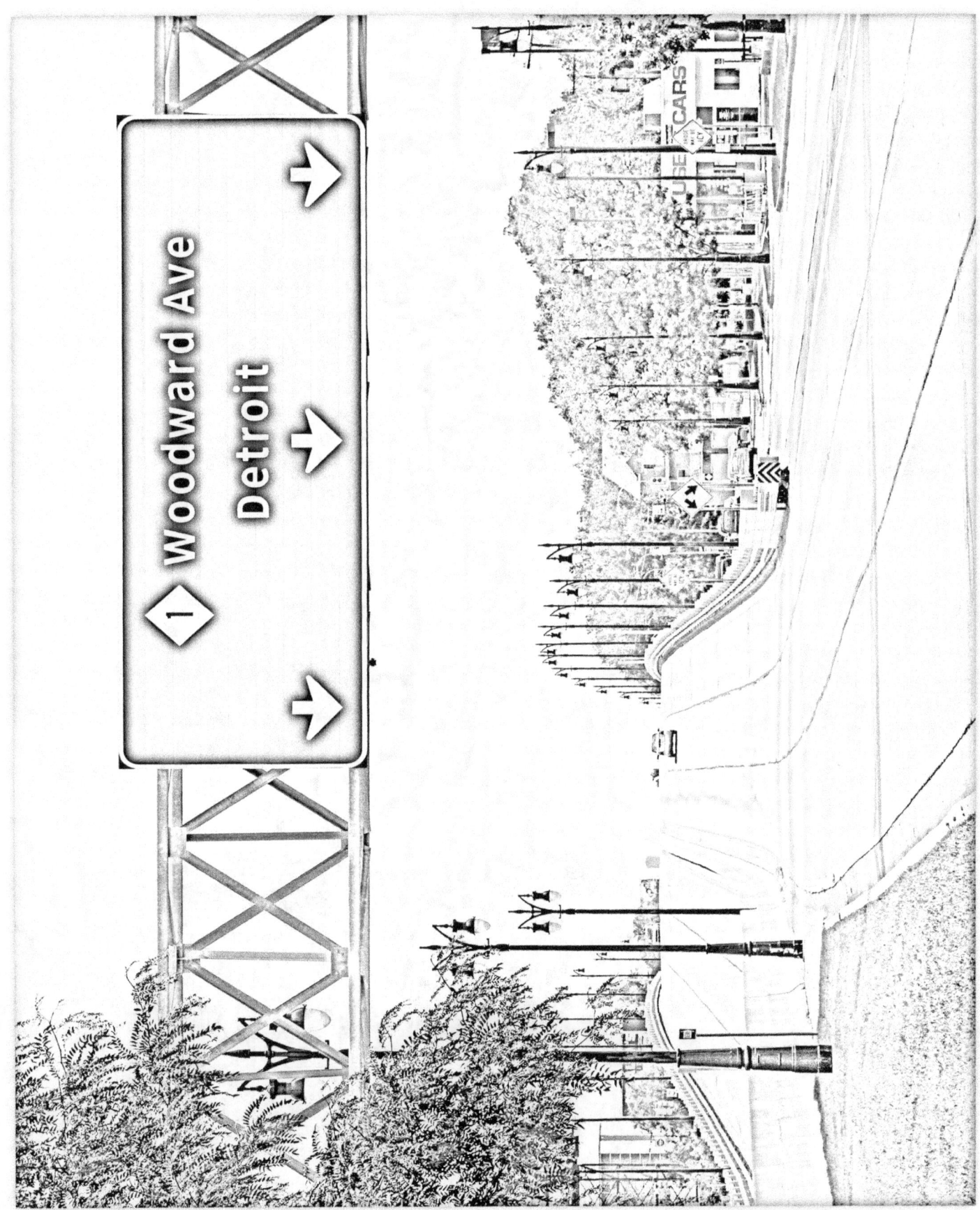

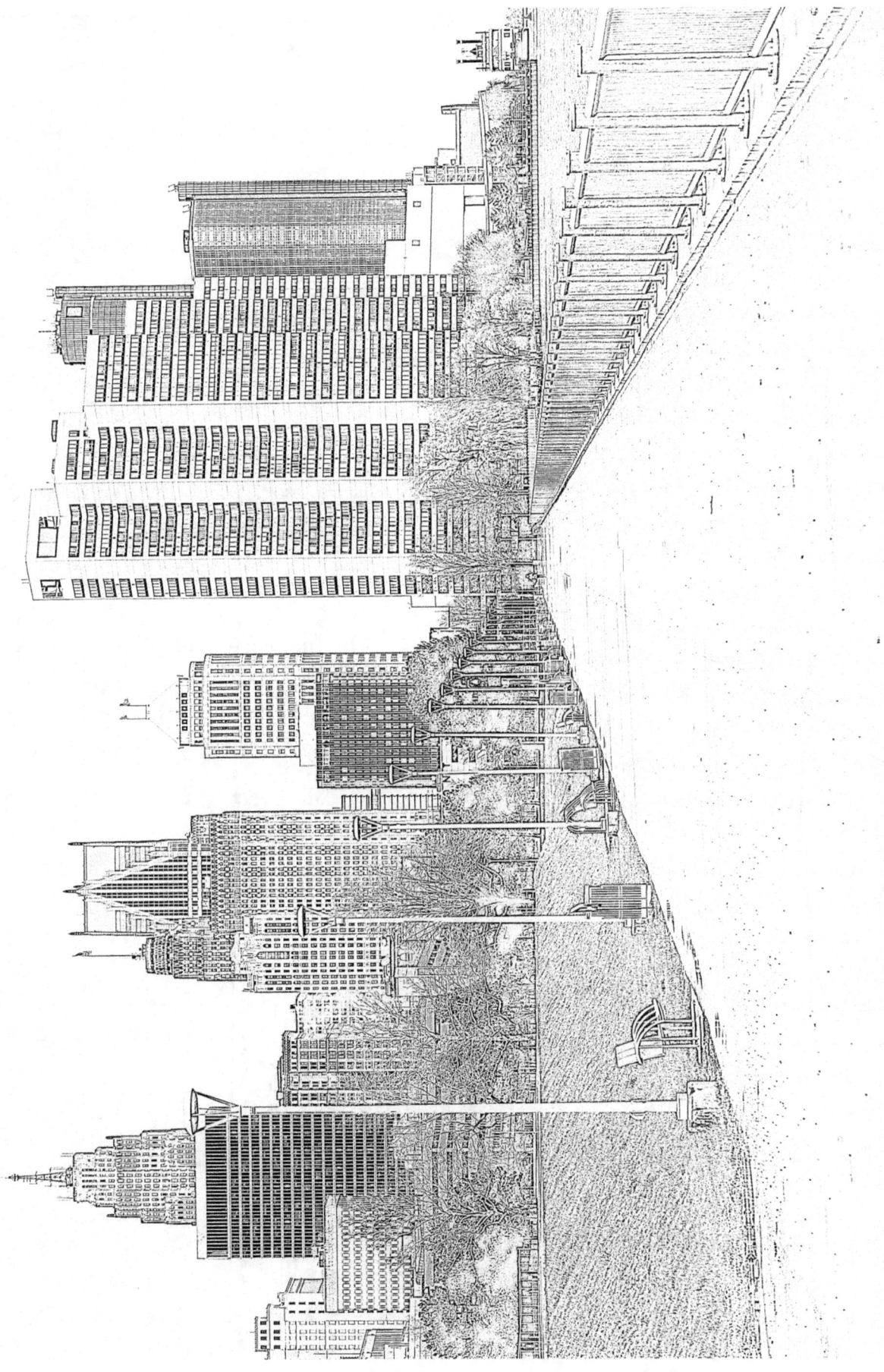

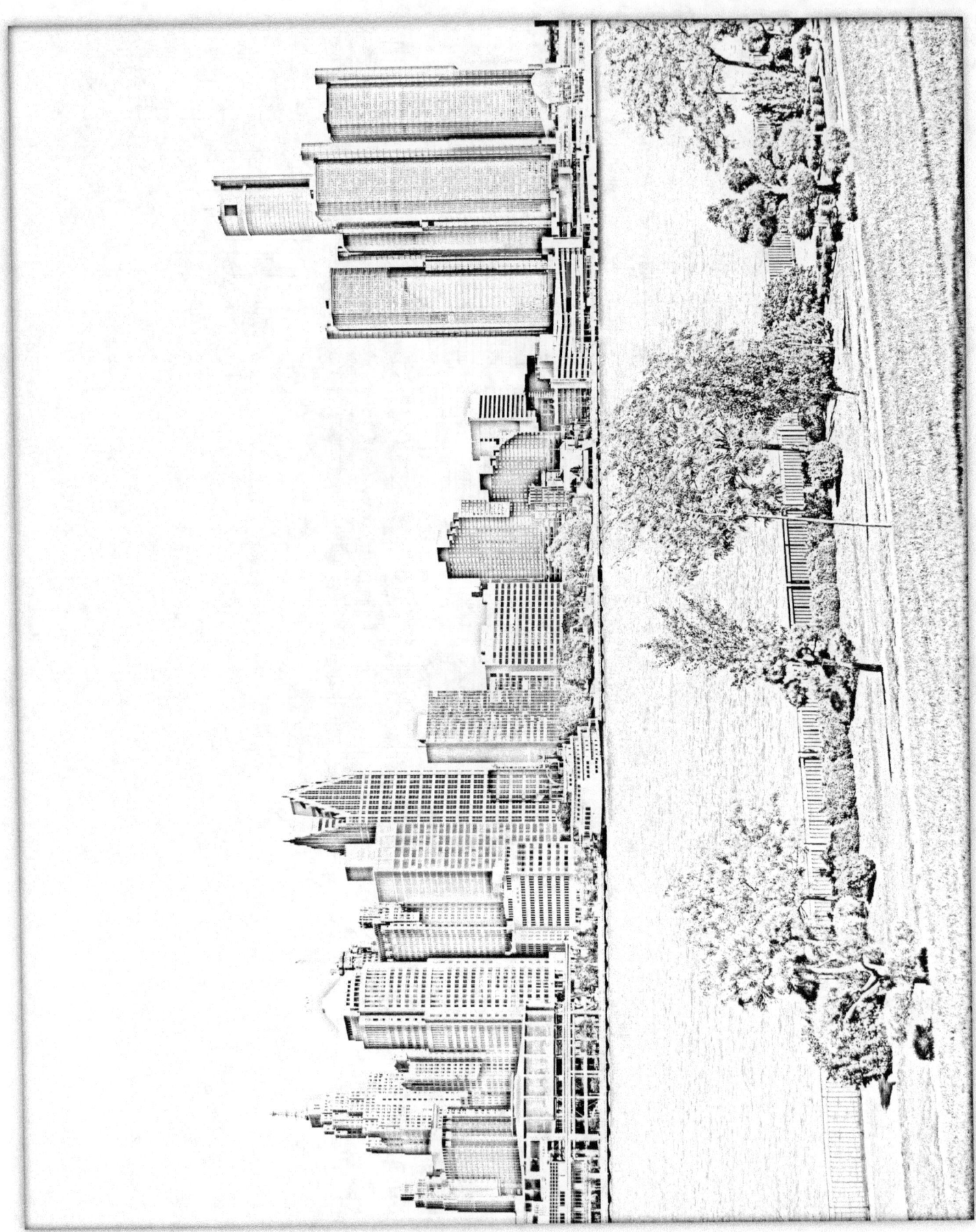

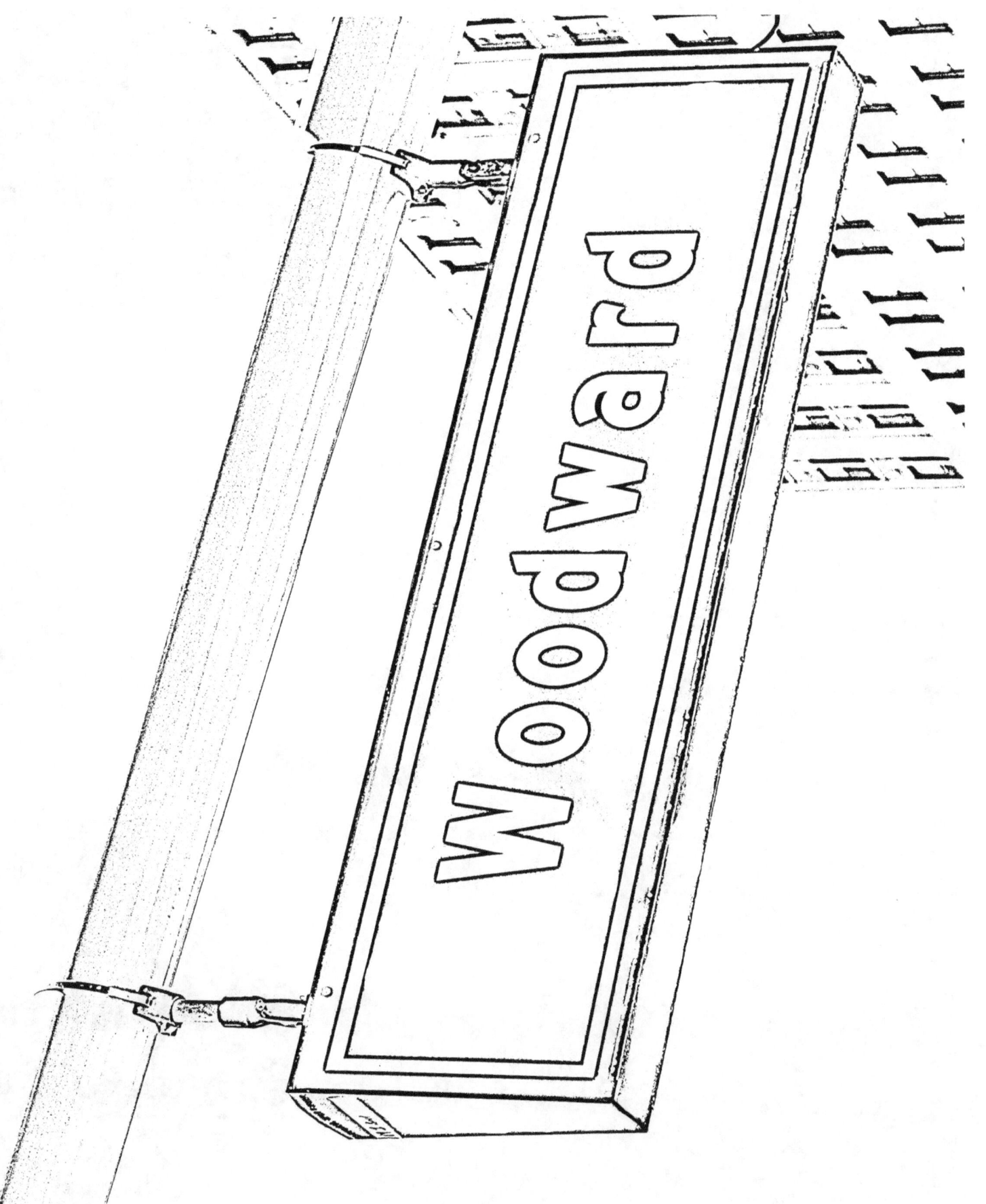

WELCOME CENTER

DETROIT EASTERN MARKET

SINCE 1891

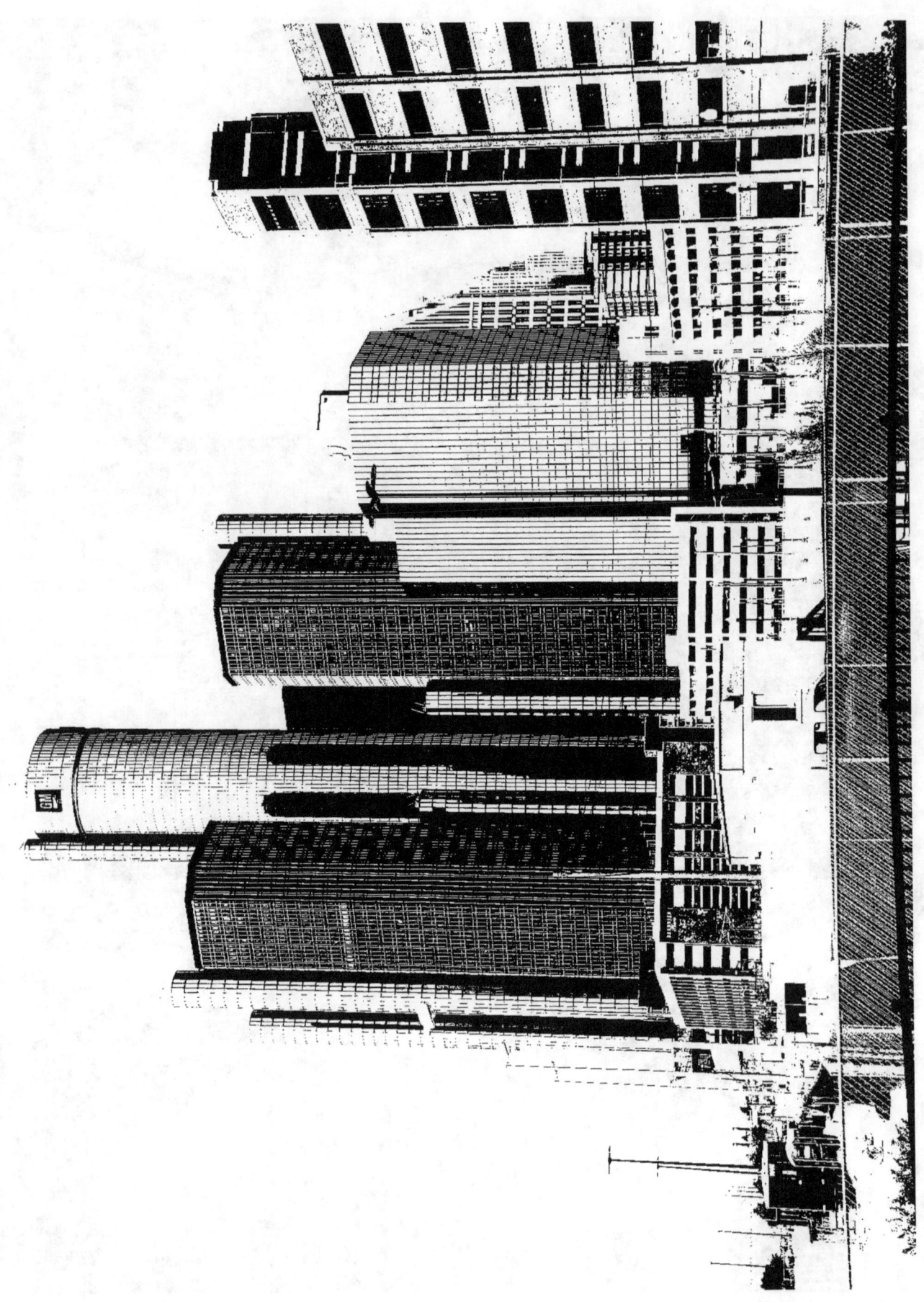

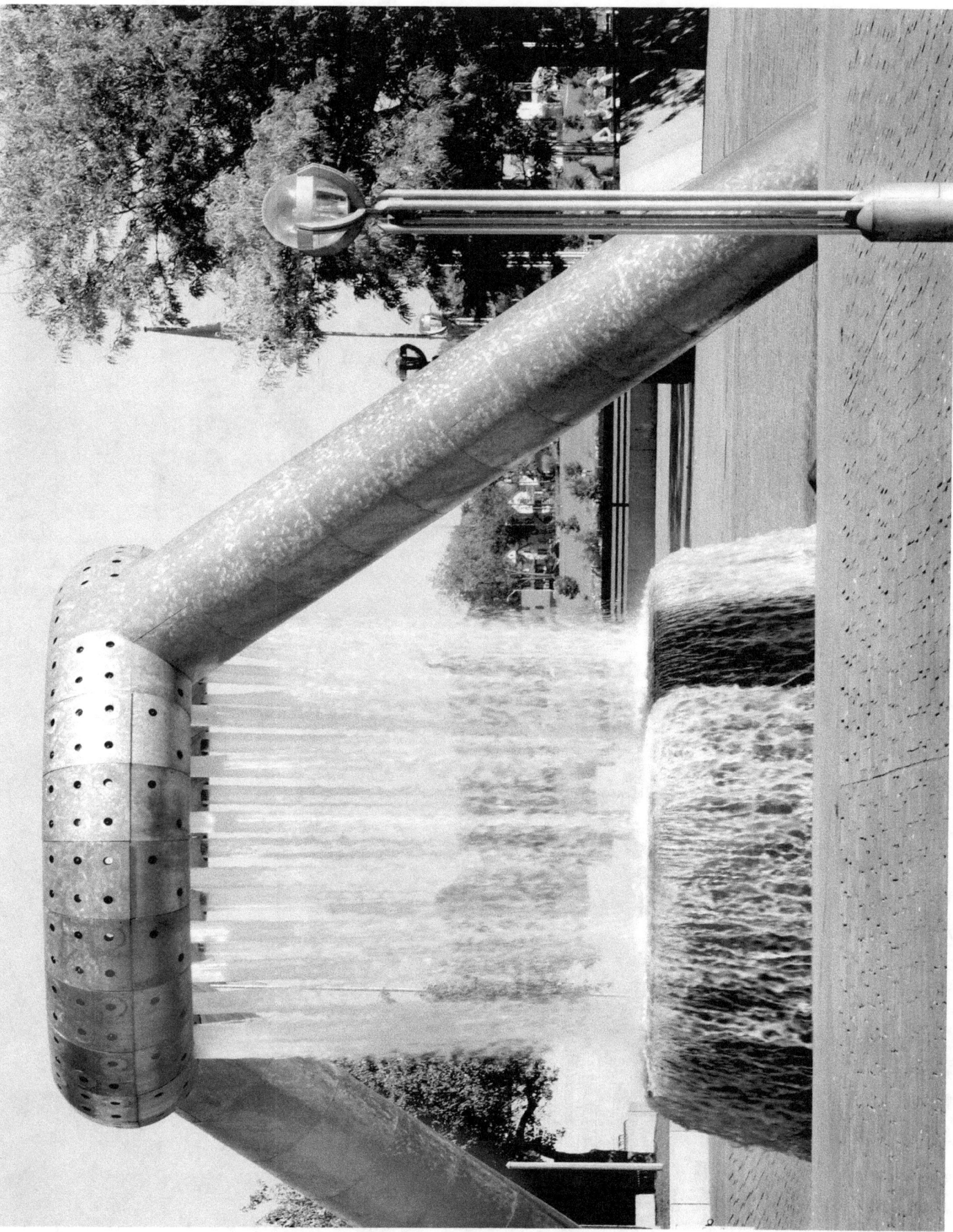

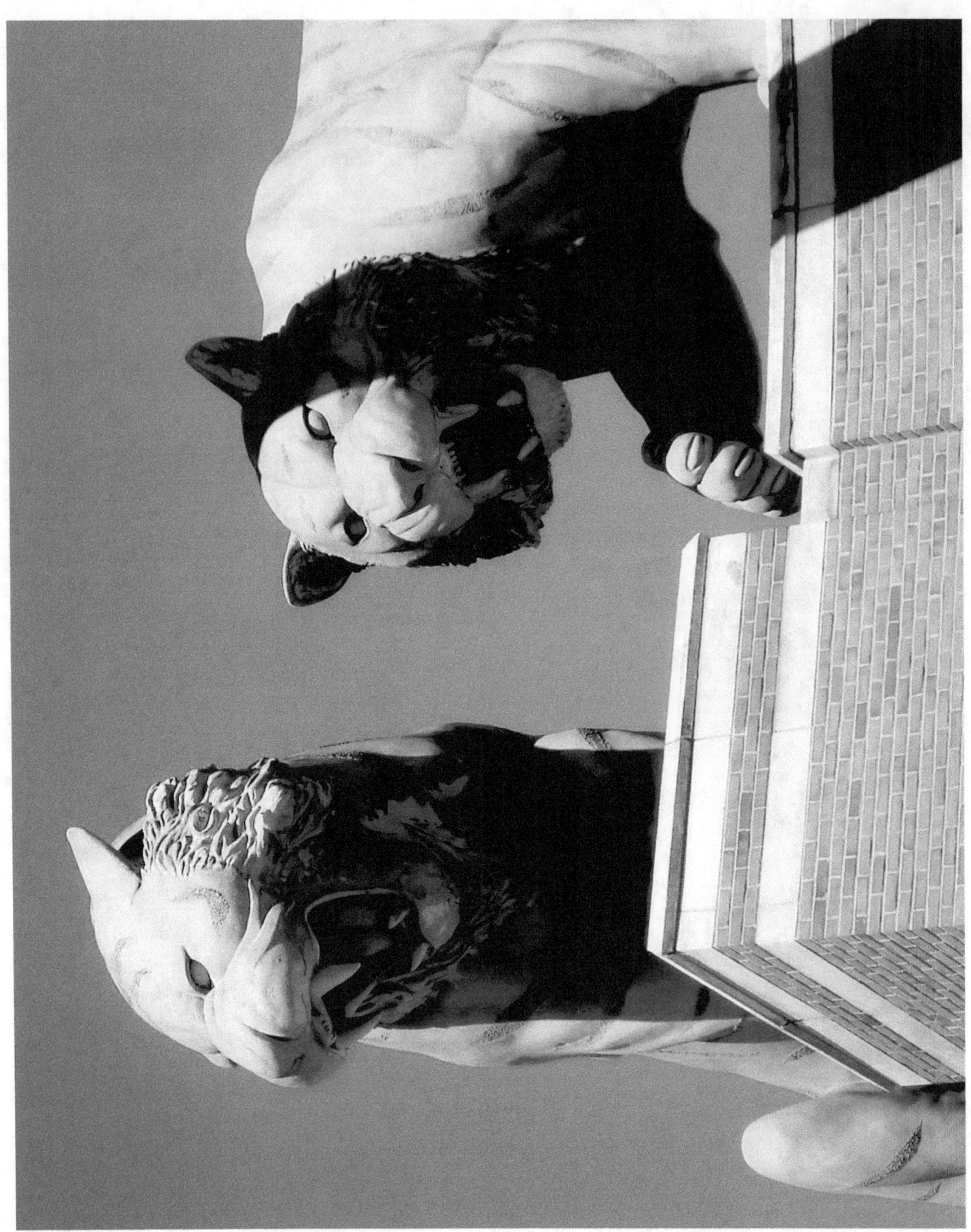

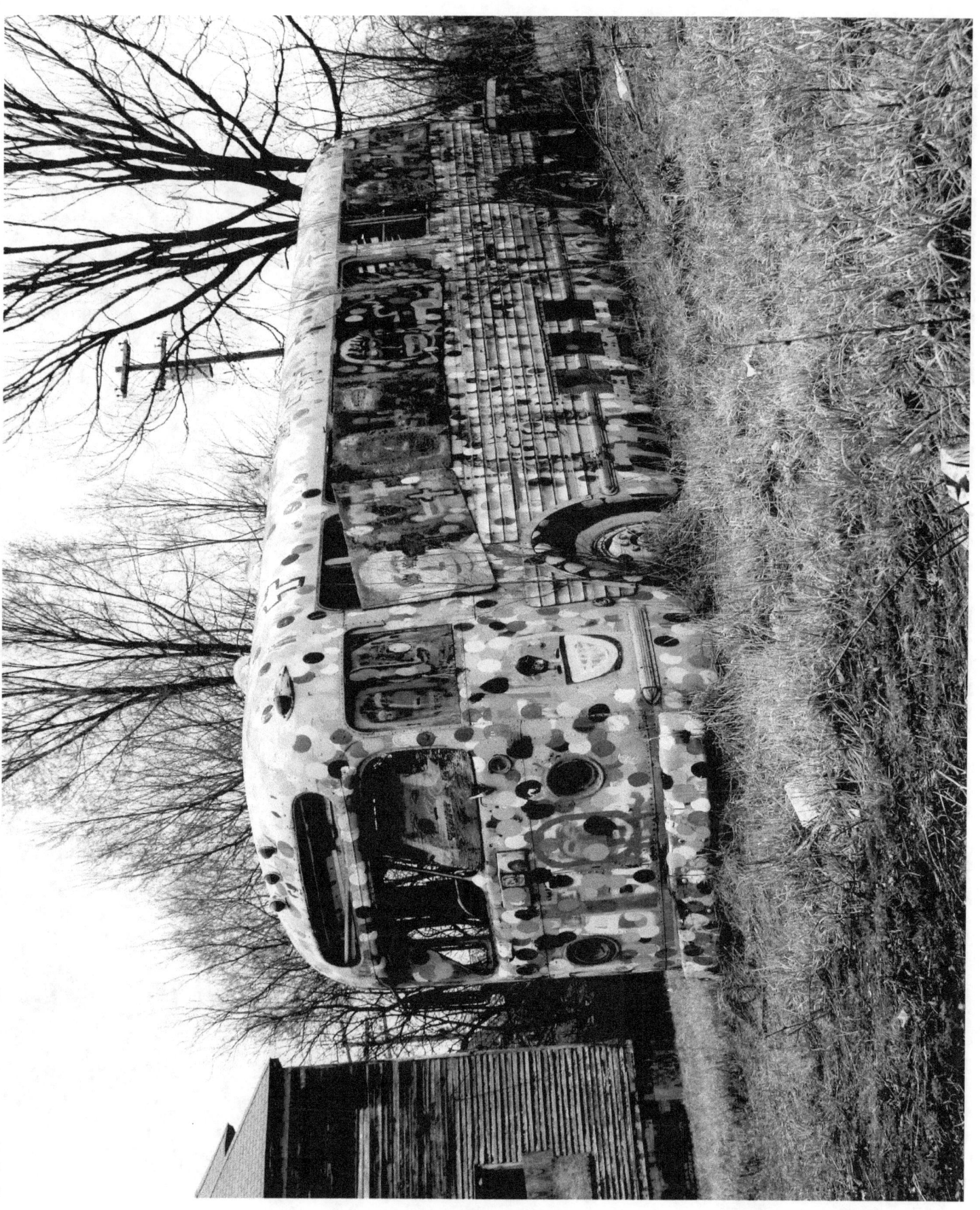

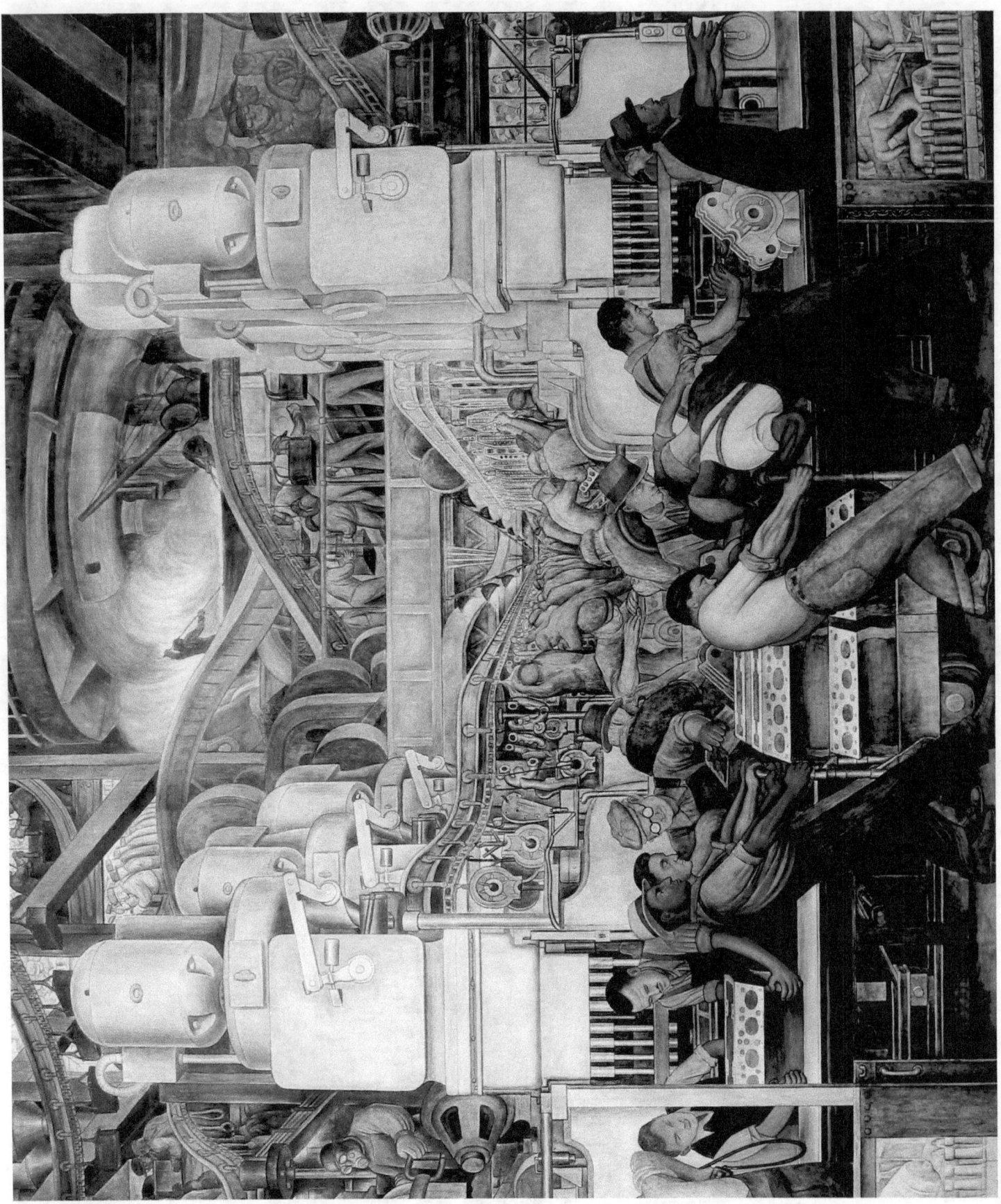

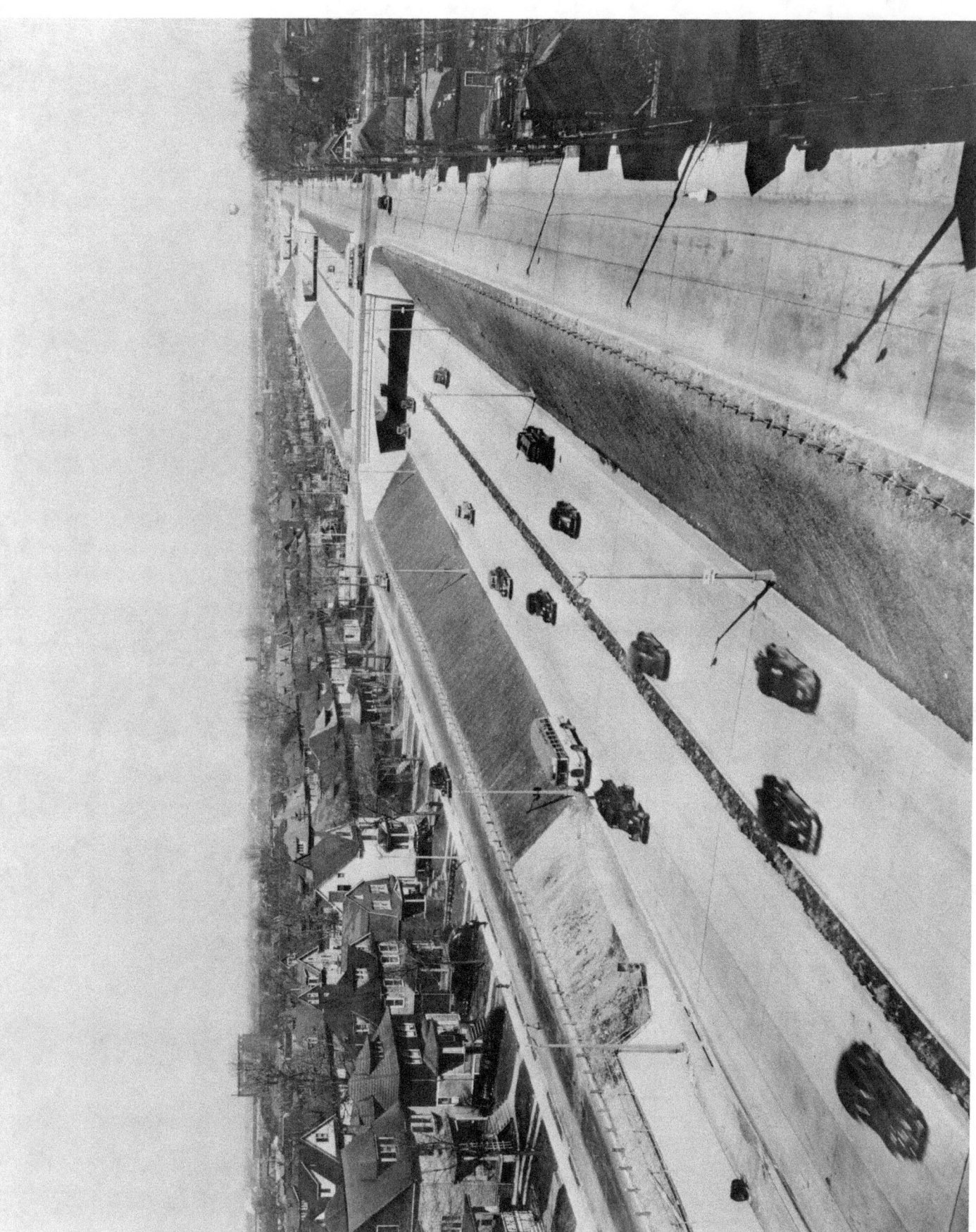

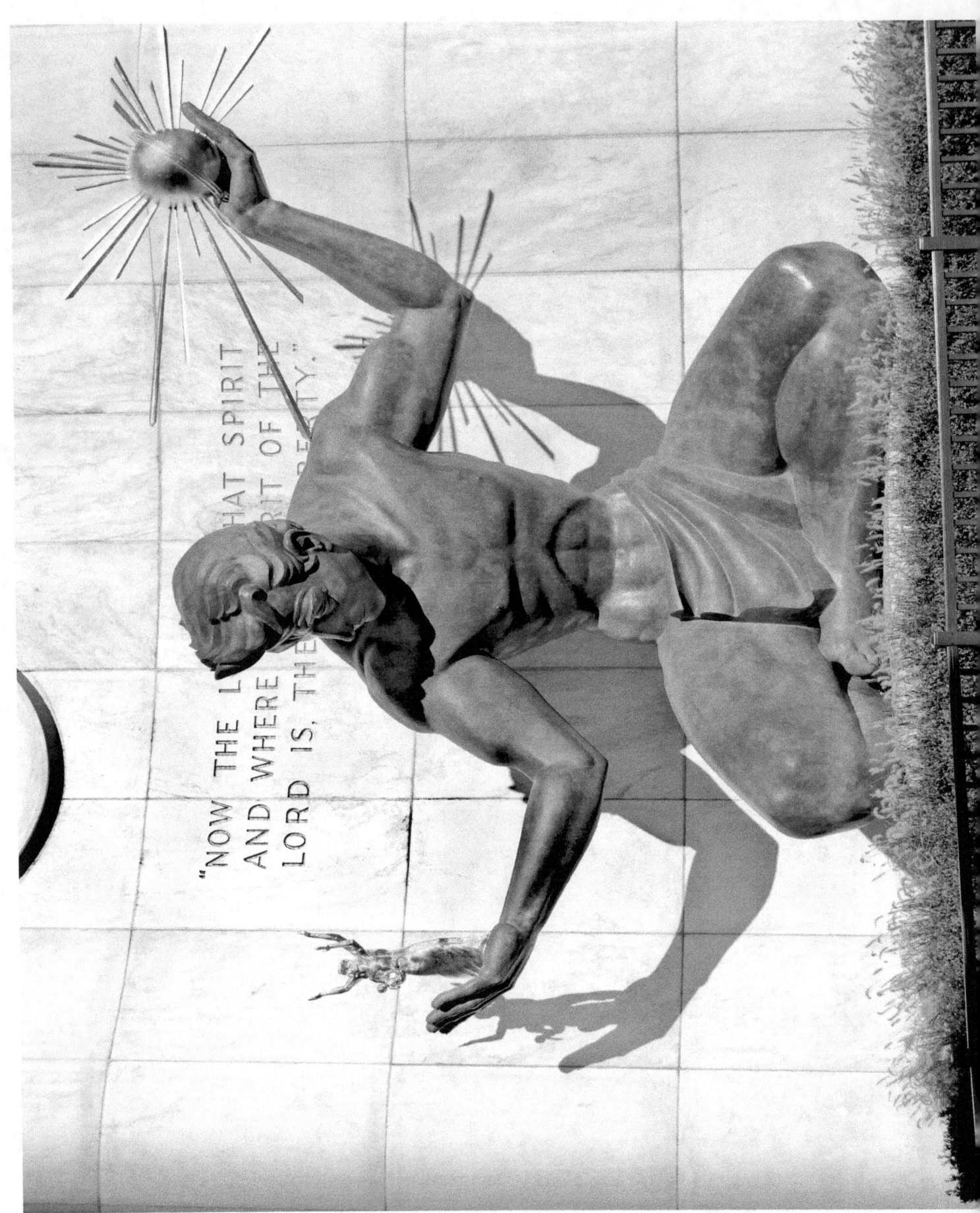

Thank You for your Support

We are looking to uplift Detroit by creating this book. A percentage of the sales for this book will be going to a charity or organization to be named later. Follow us on Facebook at **Welcome to Detroit** for news, updates, and new products. Would you like your business to be featured in future books. Please email us **at welcometodaD@gmail.**